MIGRAINE BOY

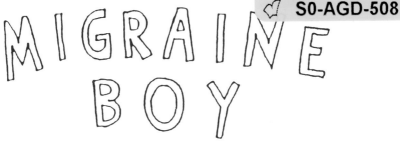

FAIR WEATHER FRIENDS

BY GREG FIERING

INTRODUCTION BY MICHAEL STIPE

ST. MARTIN'S GRIFFIN ⚑ NEW YORK

MIGRAINE BOY: FAIR WEATHER FRIENDS
©1996 BY GREG FIERING
INTRODUCTION ©1996 BY MICHAEL STIPE

http://www.migraineboy.com

ISBN 0-312-14369-9
FIRST ST. MARTIN'S GRIFFIN EDITION: MAY 1996
10 9 8 7 6 5 4 3 2 1

GREG FIERING HAS DONE GOOD—
<u>MIGRAINE BOY</u> IS A RAW NERVE
DEADPAN IN A TRANQUILIZED FLAT
WORLD. FUNNIER THAN THE ANGRIEST
DOG, FUNNY LIKE ANDY KAUFMAN,
HE IS THE HEAVY LITE CHAMPION
OF THE DAMNDEST IMPULSES.

—MICHAEL STIPE

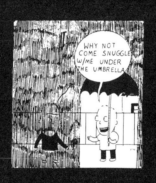

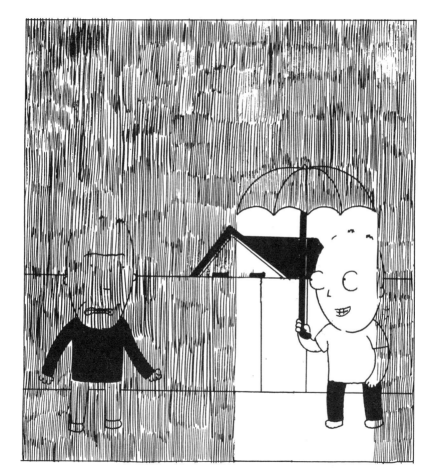

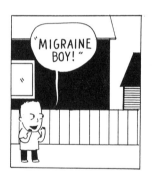
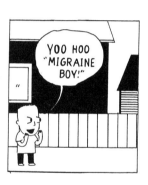

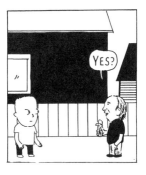
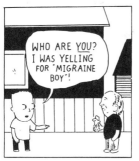
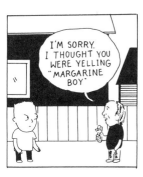

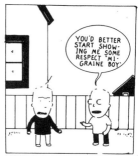
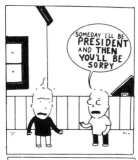
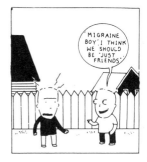
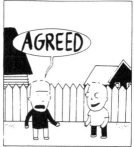
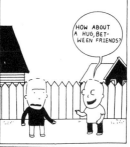
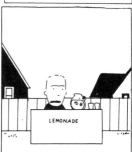
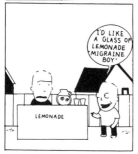

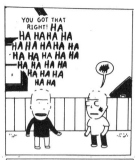
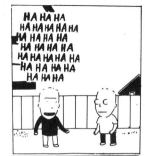
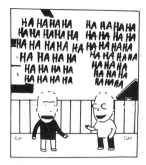
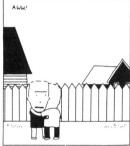
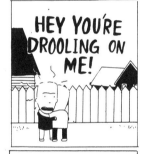
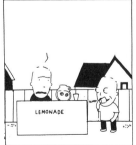
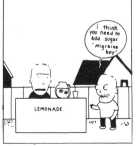
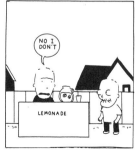

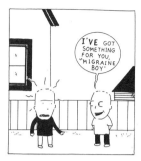

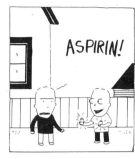

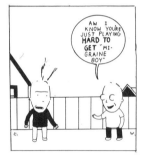

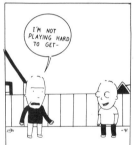

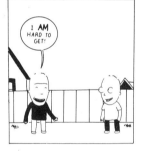

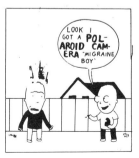

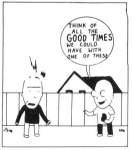

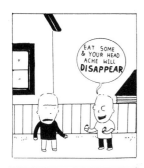

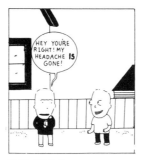

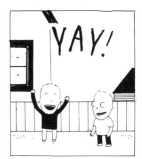

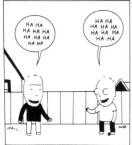

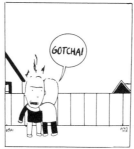

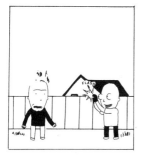

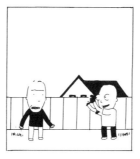

Migraine Boy '96!

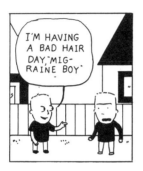
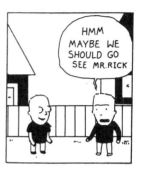

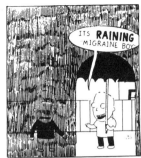

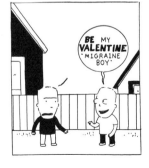

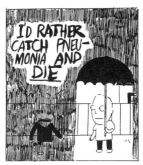
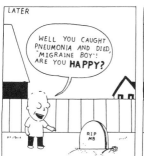
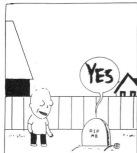
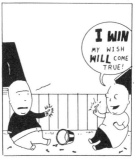
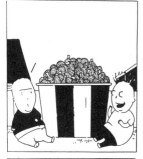
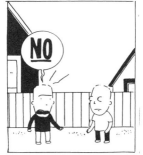

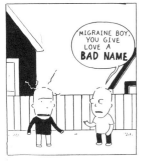

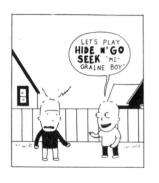
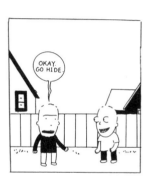

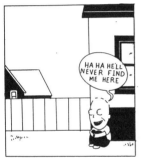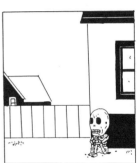

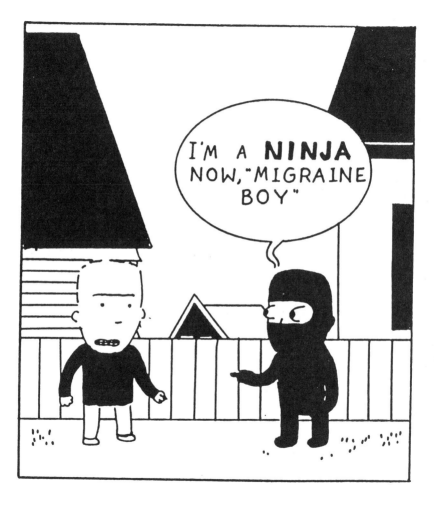

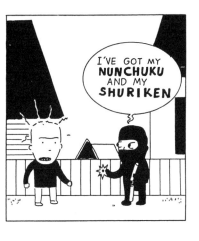
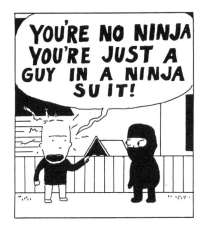
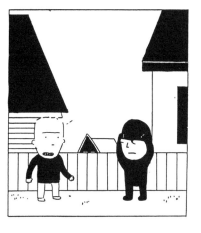
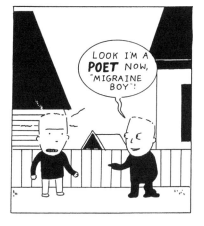

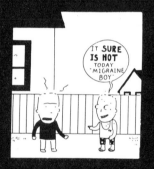

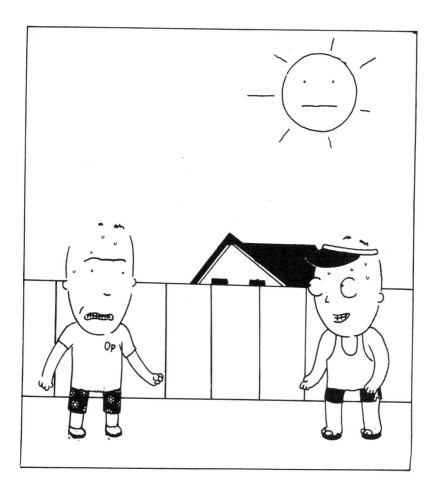

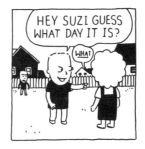

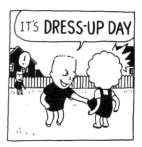

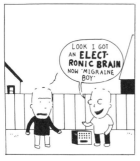

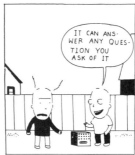

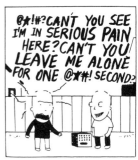

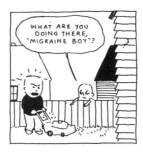

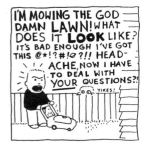

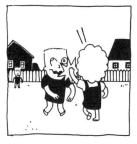

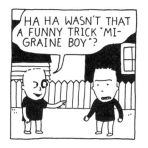

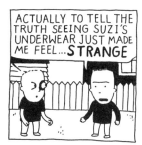

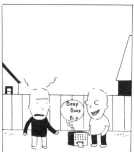

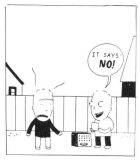

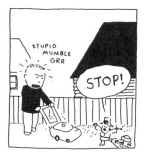

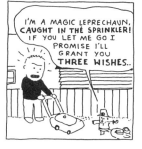

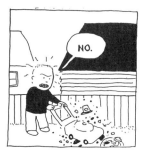

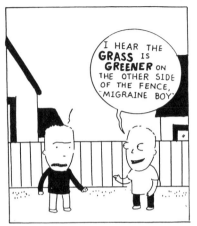
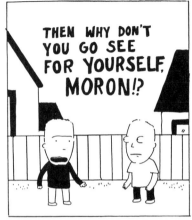
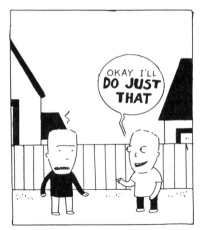
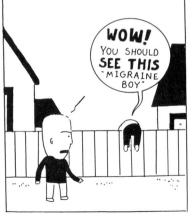

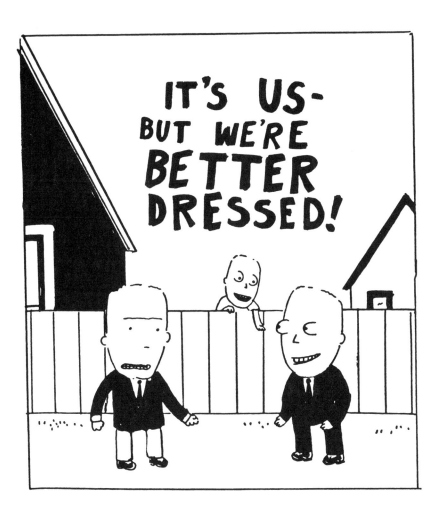

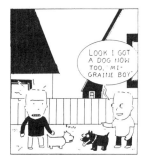
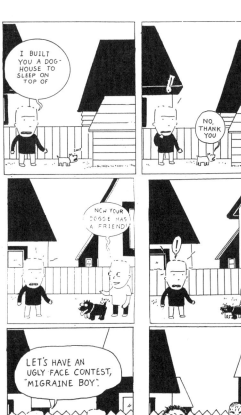
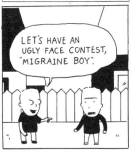

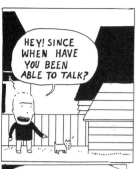

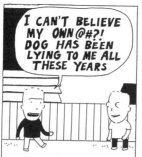

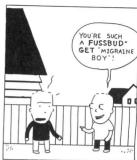

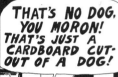

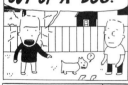

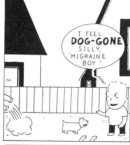

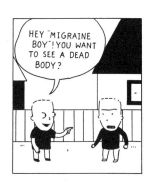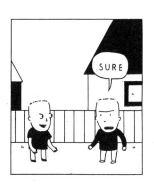

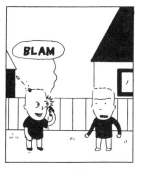
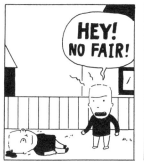
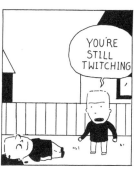

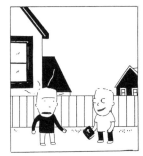
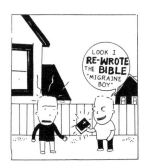
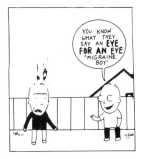
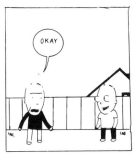
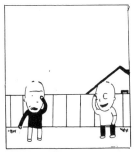

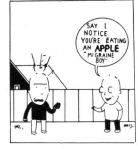

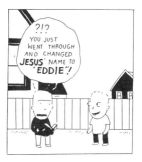

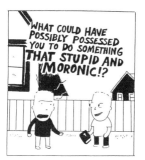

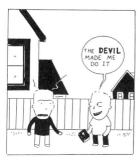

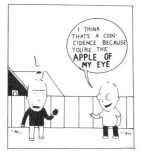

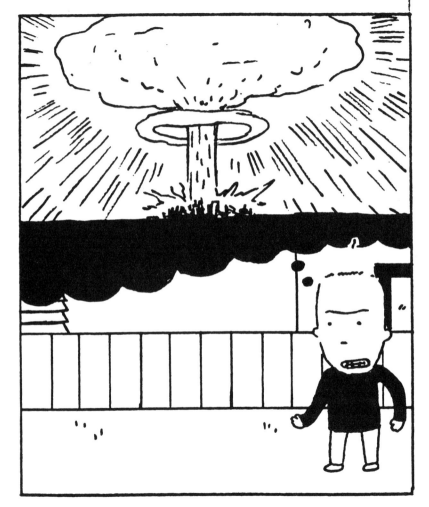

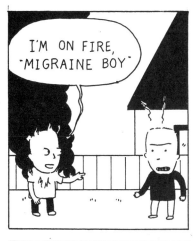
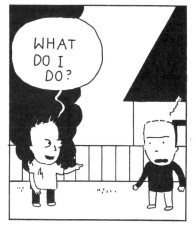
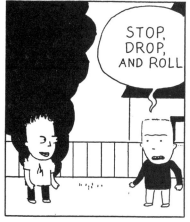
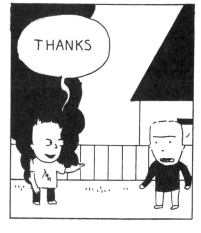

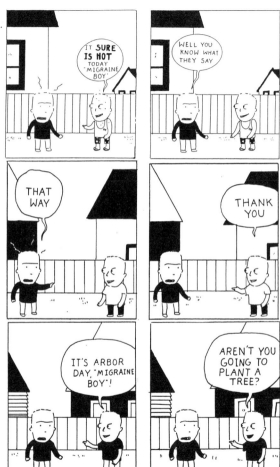
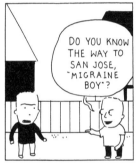

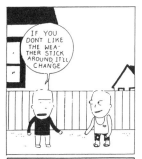
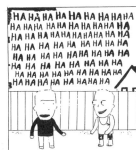
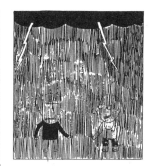

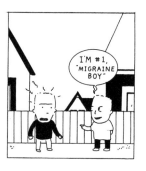

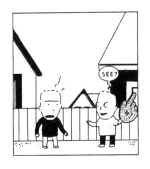
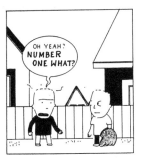
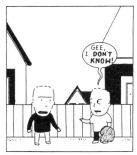

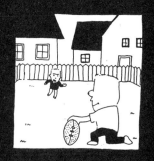

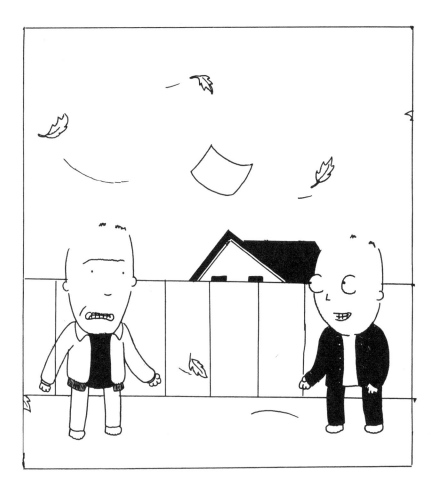

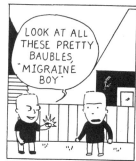
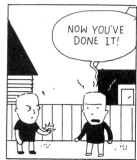
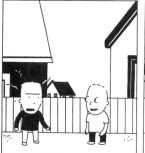
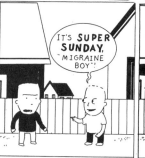
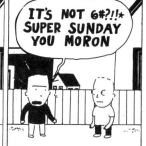
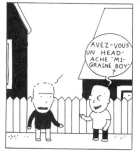
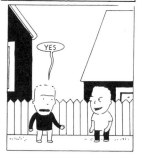

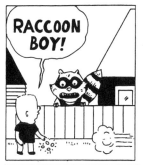

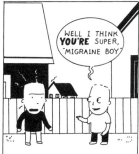
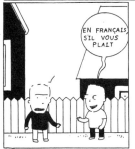
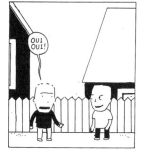
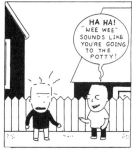

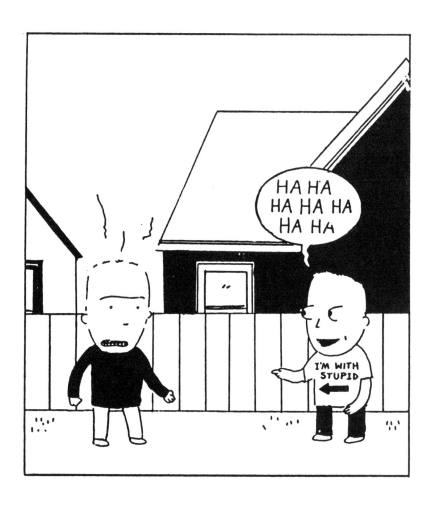

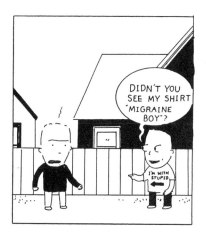

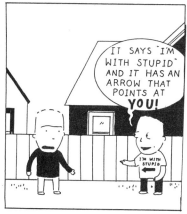

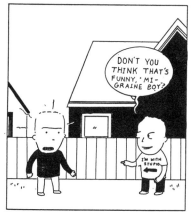

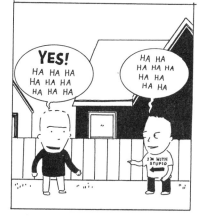

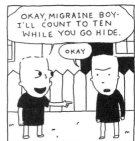

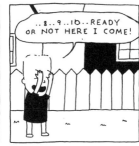

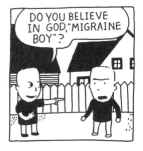

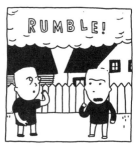

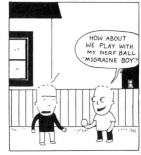

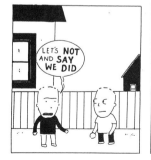
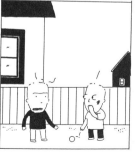
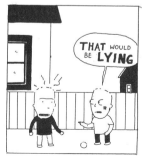

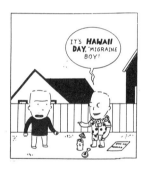 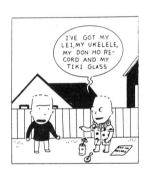

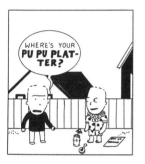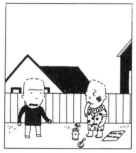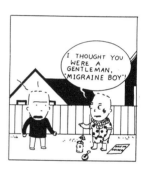

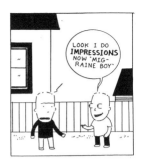
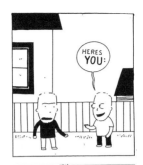
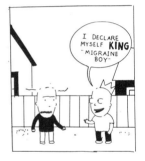
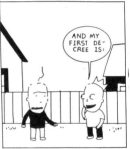
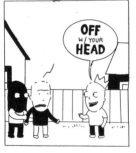
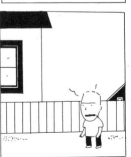
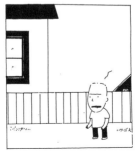

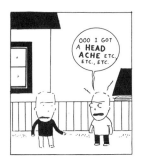
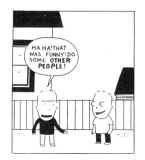
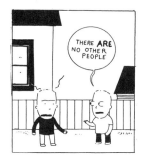
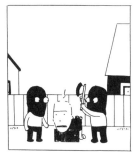
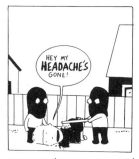

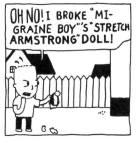

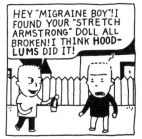

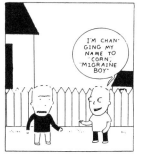

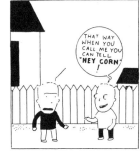

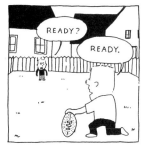
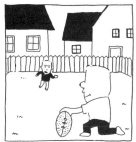
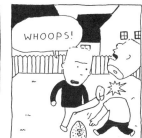
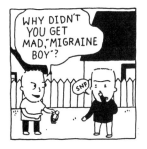
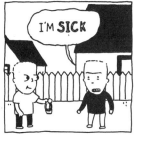
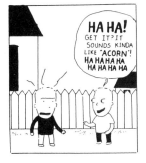

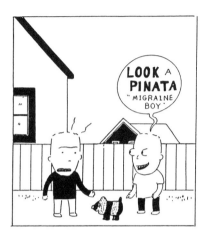

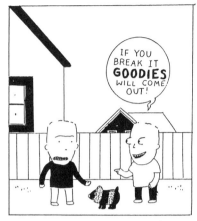

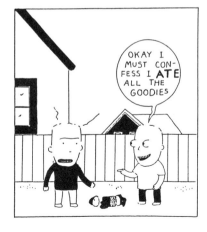

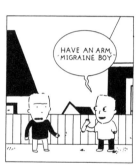

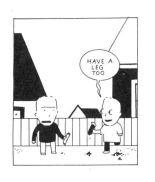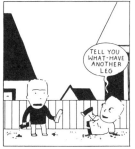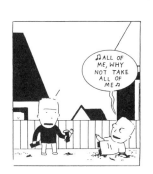

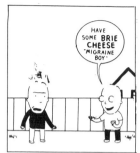
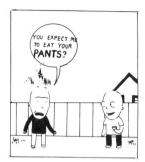
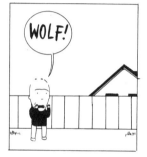

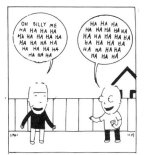
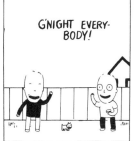
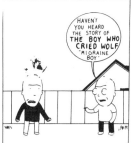
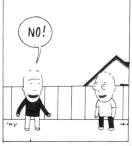
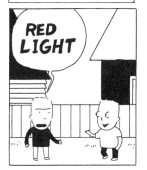

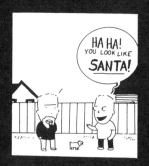

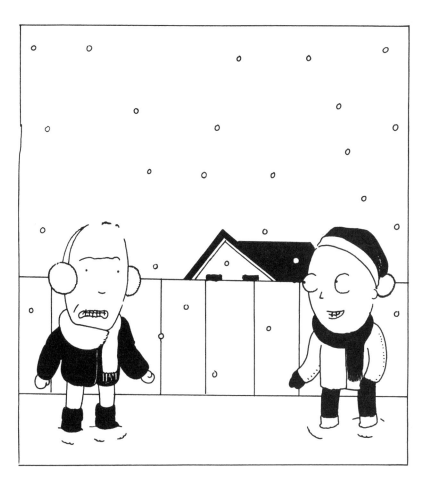

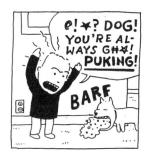

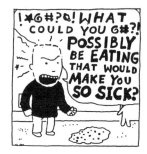

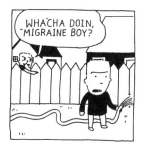

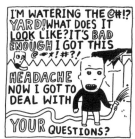

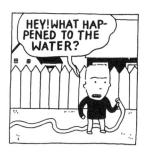

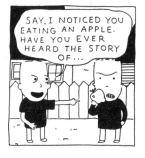

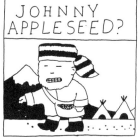

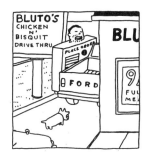
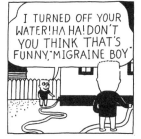
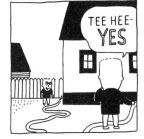
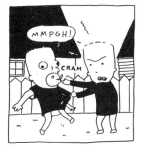
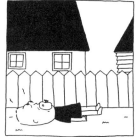
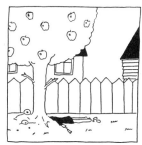

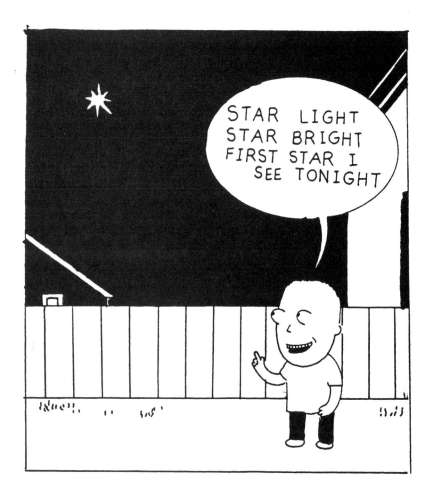

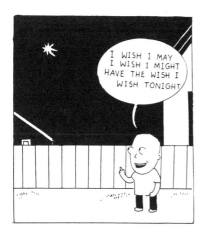
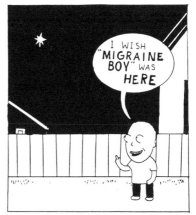
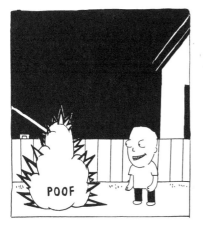
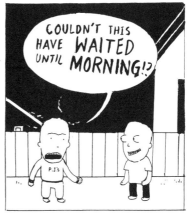

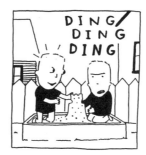
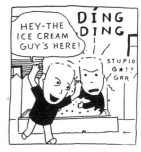

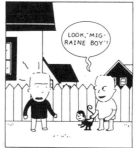
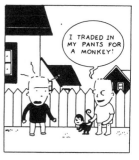
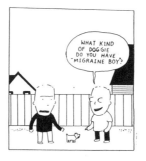
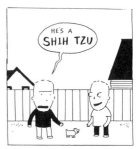

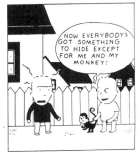
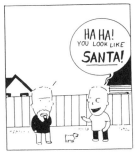
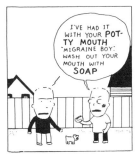
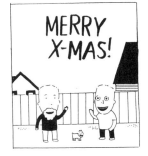

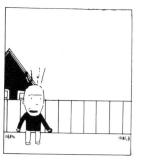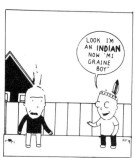

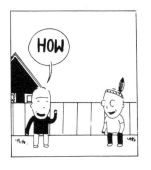 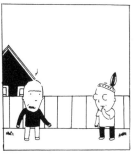 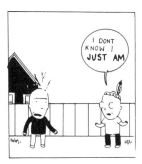

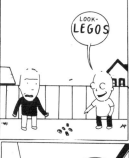

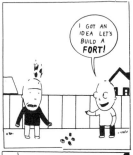

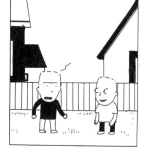

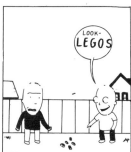

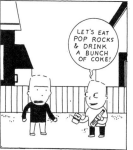

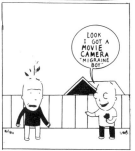

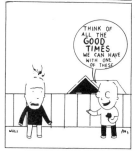

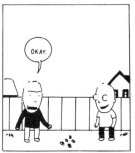
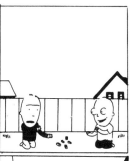
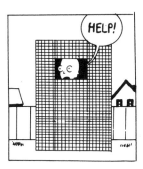
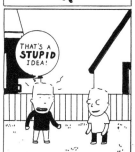
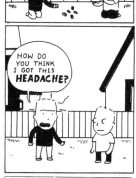
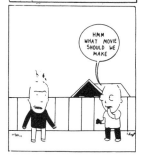
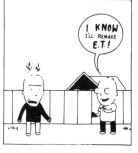
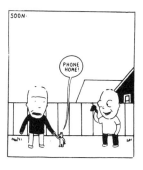

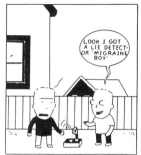

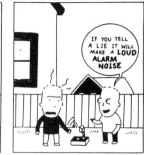

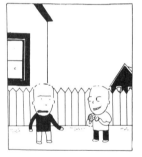

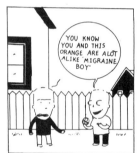

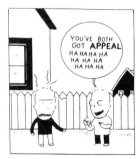

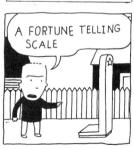

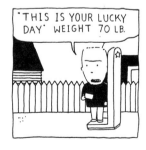

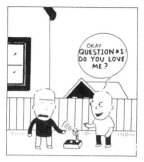
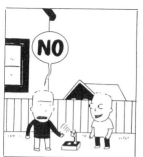
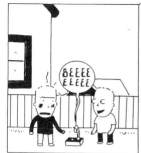
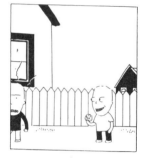

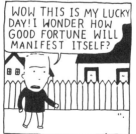
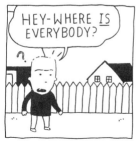
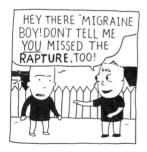

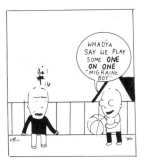
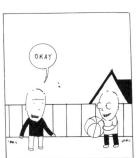

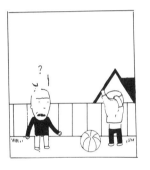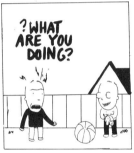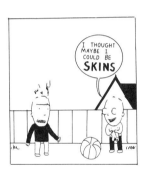

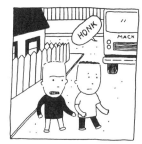
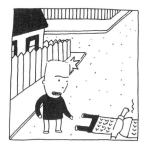
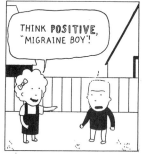

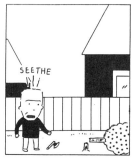
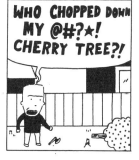

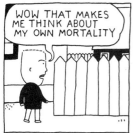

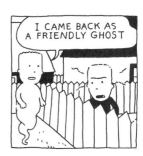

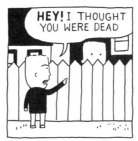

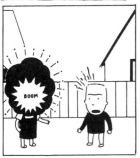

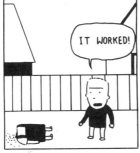

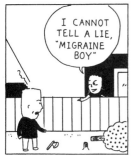

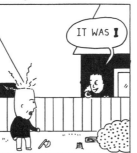

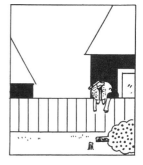

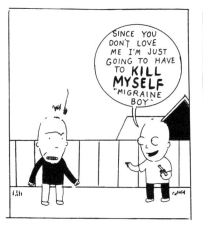

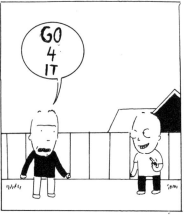

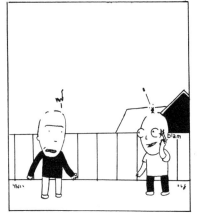

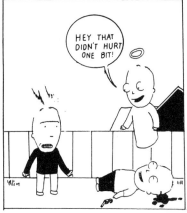

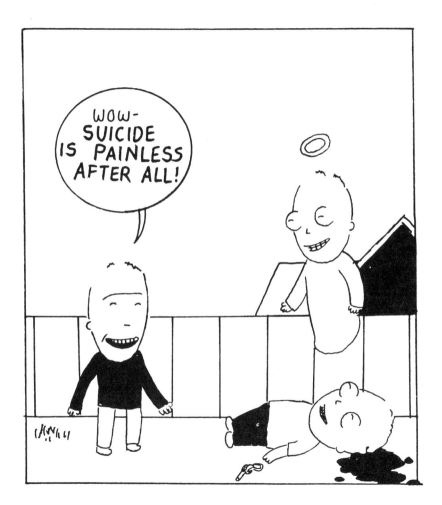

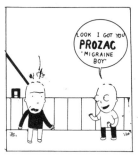
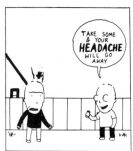
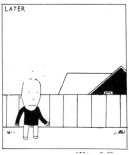
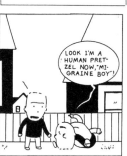
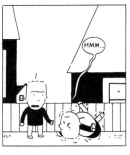

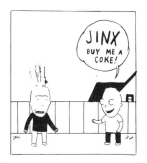
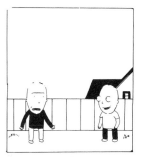
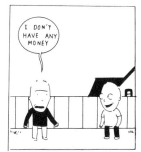
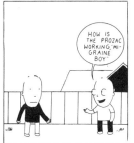
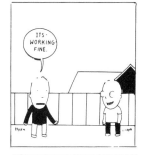
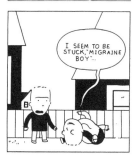
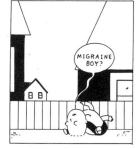
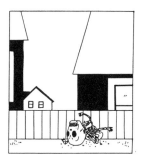

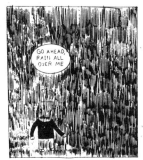
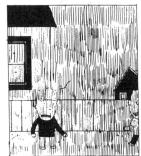
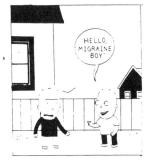
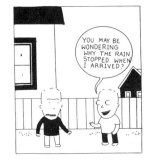